D1251323

The Owens-Thomas House

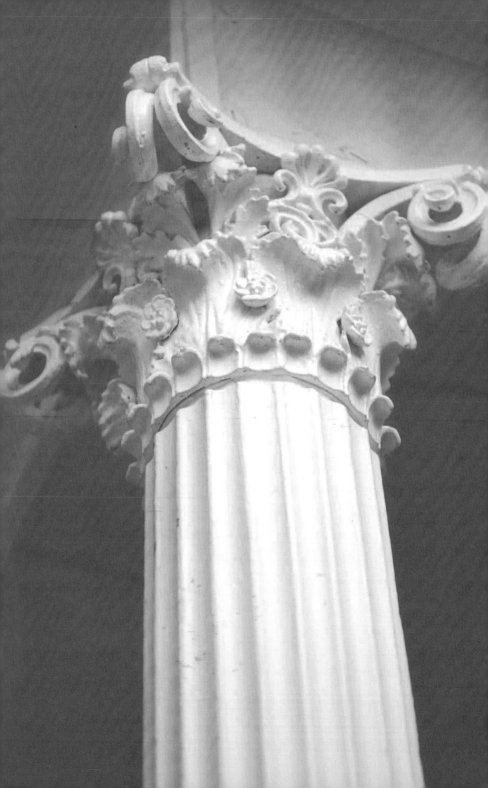

THE
Owens-Thomas
House

Tania June Sammons

Curator, Owens-Thomas House

Telfair Books

2009

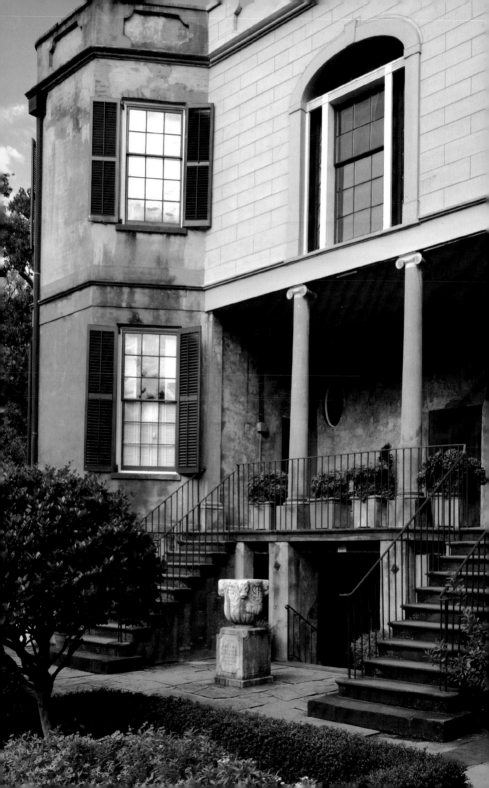

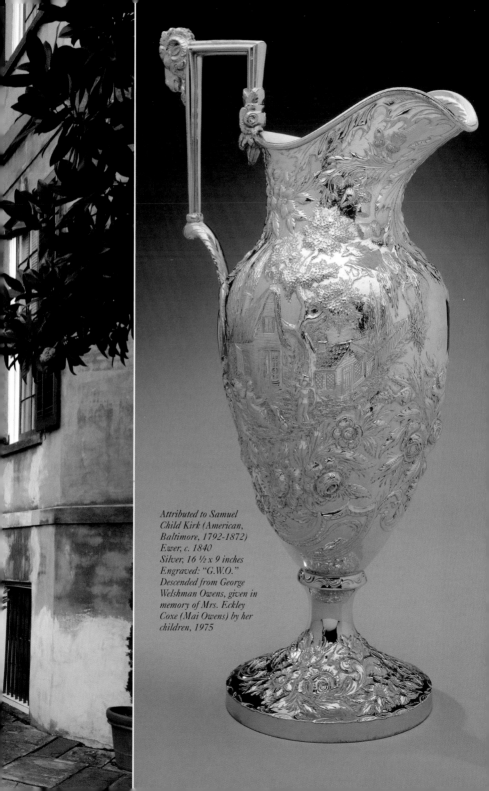

Attributed to Samuel
Child Kirk (American,
Baltimore, 1792-1872)
Ewer, c. 1840
Silver, 16 ½ x 9 inches
Engraved: "G.W.O."
Descended from George
Welshman Owens, given in
memory of Mrs. Eckley
Coxe (Mai Owens) by her
children, 1975

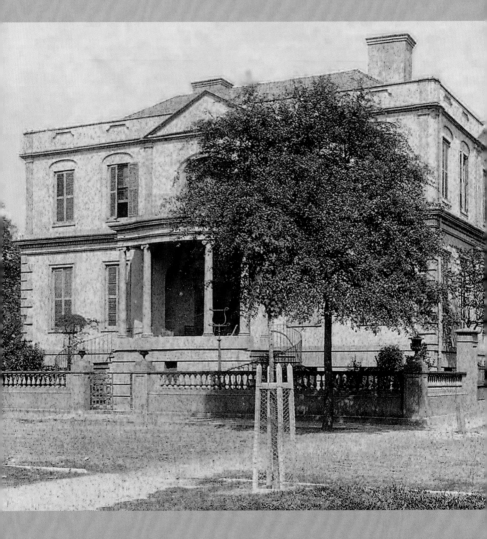

West and south elevations, early twentieth century

ʃ Introduction-

In the heart of Savannah's celebrated Historic District, on the northeast quadrant of Oglethorpe Square, stands a grand old mansion known today as the Owens-Thomas House. Designated a National Historic Landmark in 1976 and listed in the National Register of Historic Places in 1977, the Owens-Thomas House is one of three museum buildings that comprise the Telfair Museum of Art. The importance of the Owens-Thomas House lies in the site's early nineteenth century architecture, slave quarters, technology, and furnishings. With stunning Regency-style architecture, period furnishings, a rare two-story urban slave quarters and the compelling stories of its former inhabitants, the Owens-Thomas House offers national and international visitors unique insight into a young American world as it evolved in the early nineteenth century.

Mary Comer Lane (American, Savannah, 1881-1966)
Meta Thomas's Garden, *c. 1920, Watercolor on paper*
13 ⅞ x 17 ⅜ inches
Acquisition made possible by the bequest of Myrtle Jones, 2007

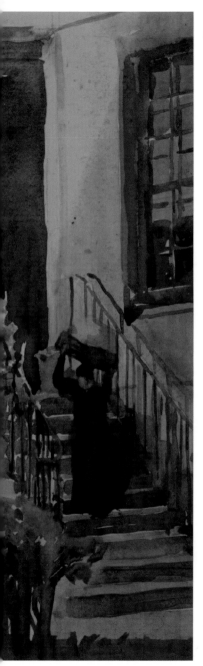

The elegant urban villa known today as the Owens-Thomas House was built on one of Savannah's trust lots, prominently located on Oglethorpe Square. As part of Georgia founder General James Edward Oglethorpe's city plan, each of these lots were originally designated for public buildings, but were later acquired and used privately. Each trust lot measured 60 feet by 180 feet on the east and west side of the square. Tything lots, intended for private residences, measured 60 feet by 90 feet and surrounded the square on the north and south side. A square and its adjacent trust and tything lots created a city ward. The property that would eventually hold the Owens-Thomas House exchanged hands several times during the eighteenth century until 1816, when the Trustees of Chatham Academy sold it to Richard Richardson for $4,500.

Richard Richardson commissioned William Jay III (1792-1837), a young architect from Bath, England, to design his home in Savannah. Richardson probably knew Jay through his brother-in-law, Robert

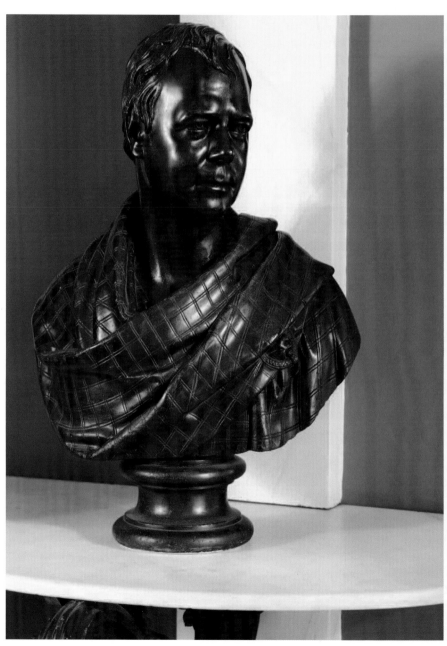

After Sir Francis Legatt Chantrey (English, 1781-1841)
Sir Walter Scott, *after 1821*
Plaster, painted to simulate bronze, 30 x 26 ½ x 16 inches
Bequest of Margaret Thomas, 1951

Bolton, who was married to Jay's sister, Anne. Jay received his training as an apprentice to David Riddall Roper, an architect and surveyor in London. He was also influenced by English architects Sir John Soane and John Nash.

By the time the twenty-five-year-old architect arrived in Savannah in December, 1817, the house was already under construction. Richardson gave Jay his first commission in Savannah, but the talented architect quickly received other commissions for both public and private buildings throughout the city, including the Savannah Branch Bank of the United States, where Richardson served as president; and the residence of Alexander Telfair, which is now part of the Telfair Museum of Art's Academy building on Telfair Square.

The style of the Owens-Thomas House, called Regency, refers to the period when King George III was declared insane and his son, the Prince of Wales, ruled England as "regent" during the years 1811-1820. After his father's death, the Prince, then King George IV, ruled until his death in 1830. When applied to architecture and the decorative arts, the term "Regency" loosely encompasses the years 1783-1840, and refers to the stylistic influence of the Prince of Wales, who in 1783 remodeled his London house using Neo-classical designs and other daring decorations.

Originally covered in pumpkin-colored stucco (later painted tan by George Welshman Owens), the symmetrical front façade features a spectacular porch with a bowed ionic colonnade and a recessed niche that creates an oval-like landing. Two semi-circular stairways reach out from the porch to invite and embrace visitors. The basement level is designed with horizontal rusticated bands, and quoins encapsulate the first story. Arches decorate the second story windows, and a parapet wall tops the structure on all four sides. When George Welshman Owens acquired the property in 1830, he added three rooms to the second story above the lower bay rooms and porch at the rear of the house.

This impressive two-story residence rests over a raised basement and is built of fire resistant materials

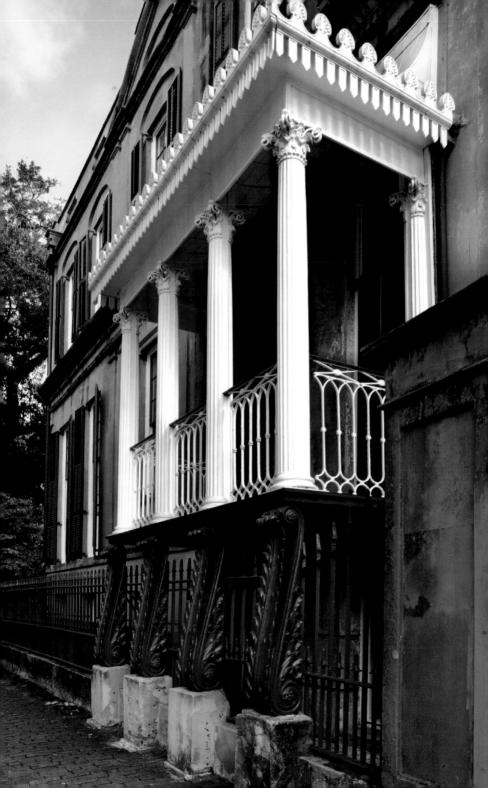

such as iron, brick and tabby. Tabby, used on the basement and first floor of the main house and also in the carriage house, is a concrete-type material made of lime, oyster shells, water, and sand. A cheap, readily available material often used throughout the Georgia and Carolina low country, tabby proved stronger than traditional brick and mortar when used in construction. The second floor of the house is made of brick and coquina, a natural limestone formed from shells and coral that is lighter than tabby. Exterior walls are 22 to 24 inches thick and interior walls 12 to 18 inches thick. Iron is used in floor joists, columns, shutters, windows and stair banisters.

Shipped from England in pieces and assembled on site, one of the mansion's most distinctive exterior features is the cast-iron balcony on the south façade. Although the use of cast iron was fairly common in England, this balcony represents the first large-scale structural application in American architec-ture. Jay worked with local planter and businessman Henry McAlpin, the owner of nearby Hermitage Plantation (known for its brick manufacturing) to establish a foundry to supply the iron that was needed for the architect's structures in America.

The most technologically advanced feature of the house was the plumb-ing system. Gutters on the roof collected and transmitted water through a series of cisterns throughout the house that fed two water closets (toilets), multiple sinks, three bathtubs, and at least one shower. Two existing sinks remain in the basement's laundry room, and remnants of two marble tubs remain in the bathing room, as does the shower. Presumably only the white members of the household were permitted to use the indoor plumbing. The enslaved members of the residence used a two-seated privy (outhouse) located at the back of the garden. The kitchen, also located in the basement, featured a new "modern" range, imported from England.

The "Lafayette Balcony," on the south elevation

The Interior

Regency style broke sharply from the rococo and baroque eras that preceded it with an affinity for simpler lines and more restrained ornamentation. With symmetry as the dominant design rationale, the Regency style also featured neo-classical and ancient Egyptian influences, daring architectural innovations, vibrant and exotic colors, uniquely-shaped rooms and interior spaces, the use of decorative false finishes, gilded details, painted ceilings, and impressive and graceful staircases. The Owens-Thomas House offers visitors a closer look at this exciting early nineteenth century approach to interior design.

Detail of gilded Corinthian column, above.
At right, the grand staircase

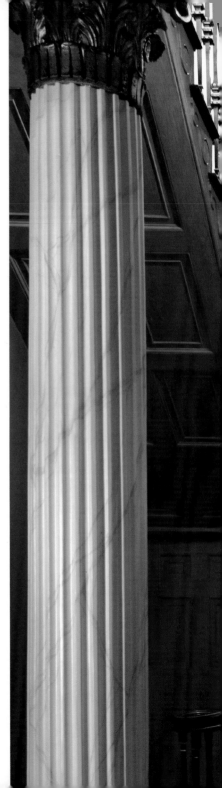

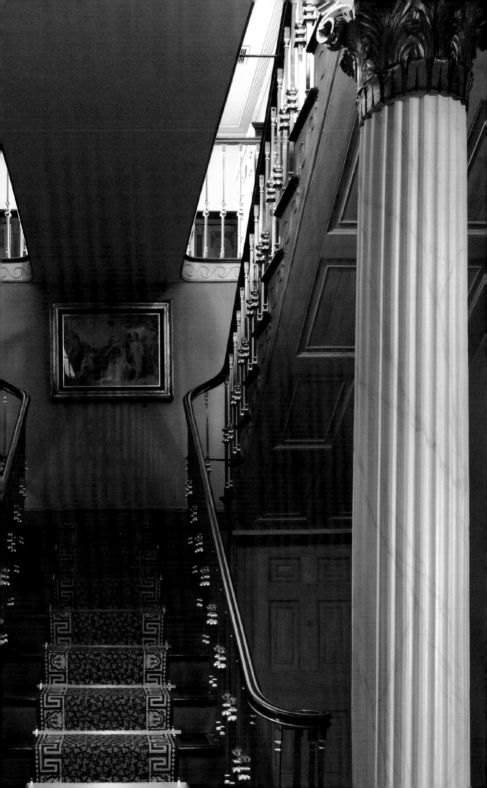

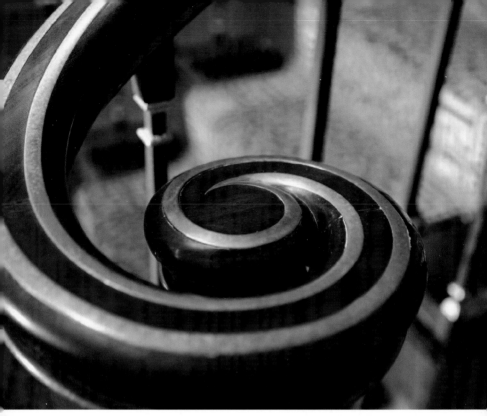

Detail of brass-inlaid mahogany handrail

𝒮ront 𝓔ntrance

Visitors entering the mansion are often struck by the bold elegance of the interior space. Two fluted columns with gilded Corinthian capitals resting on plinths visually separate the reception area from the grand staircase. Both columns and plinths are made of Georgia pine and painted to look like marble, a popular but expensive decorative technique employed during the nineteenth century. The stunning mahogany, brass, and iron staircase rises to a landing, splits into two flights, and culminates in a bridge that spans the stairwell and connects the front and rear portions of the second floor. The woodwork is grained to look like red oak, and the cast-iron balusters are painted to appear bronze.

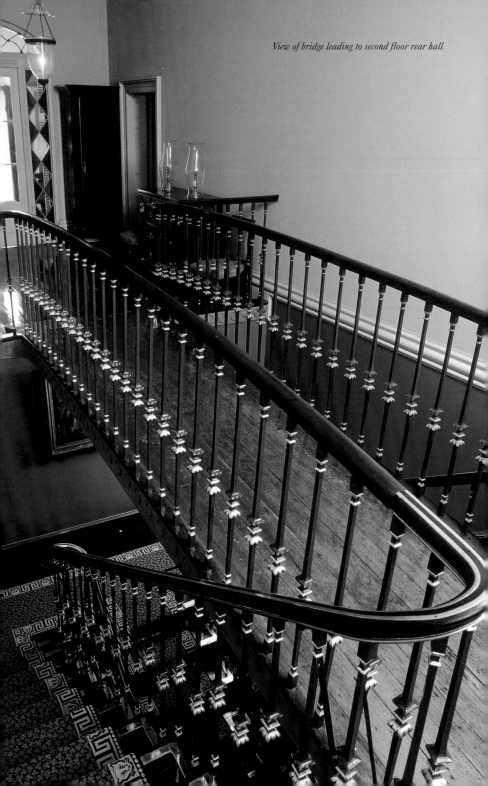
View of bridge leading to second floor rear hall

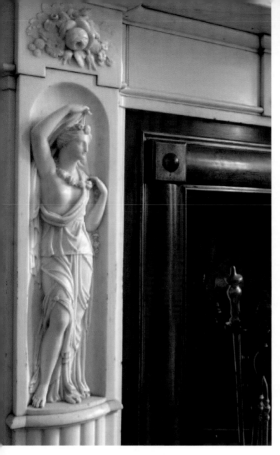

Detail of drawing room mantel, attributed to Richard Westmacott Jr. (1799-1872)

Detail of corner plasterwork features gilded bracket, Greek-key frets, and false silk wall finish

According to modern paint analysis, the green wall finish and other decorative finishes in the space date to the 1830s Owens era. Two built-in demi-lune marble console tables in the front entrance hold busts of Sir Walter Scott and Lord Byron. Both statues, made of plaster but painted to look like bronze, belonged to George Welshman Owens.

Drawing Room

One of Jay's most elegant creations is the drawing room. Located to the south of the entrance hall, this square room boasts a slightly curved ceiling accentuated by plasterwork at each corner, made to look like gathered fabric. A painted cloud scene (recently recreated after extensive paint

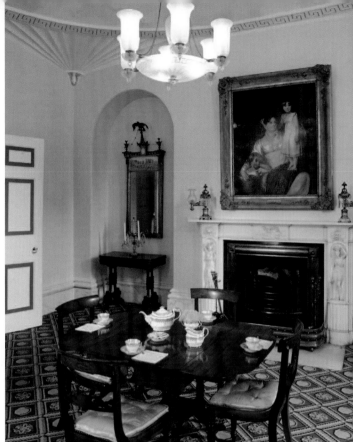

Drawing room

analysis revealed original finishes) opens the heavens, while a pink glazed wall replicates silk wall hangings. The total effect gives the illusion of a domed, or tented, room. Jay topped off the décor with a circular Greek key design encapsulating the heavens, as well as gilded accents on both the center medallion and the corner moldings. Two niches on the east wall frame a stunning white marble mantelpiece featuring two classically-draped female figures, attributed to English sculptor Richard Westmacott Jr. (1799-1872), an associate of William Jay.

This room, as well as the dining room across the entrance hall on the north side of the house, is interpreted to reflect the Richardson

era in the 1820s. The Brussels-woven carpets in both the drawing and dining rooms are period reproductions, recently reintroduced to simulate the Brussels carpet listed on Richard Richardson's 1822 Bill of Sale of Household Furnishings. Period appropriate reproduced ottomans and window treatments were also noted in Richardson's inventory.

Dining Room

Like the drawing room, the dining room was used for entertaining and showcased the family's finest furnishings as well as William Jay's spectacular design skills. Early nineteenth-century diners wanted their dining rooms to feel secluded in order to create a subdued, striking atmosphere. The muted gray color of the room recreates the Richardsons' 1820s color scheme, establishing a somber feeling in the room, in contrast to the original red color probably chosen by William Jay. However, other dramatic effects created by Jay in the house's largest room remain intact, including the Greek key skylight made of amber glass, which bathes the darkish room in warm light throughout

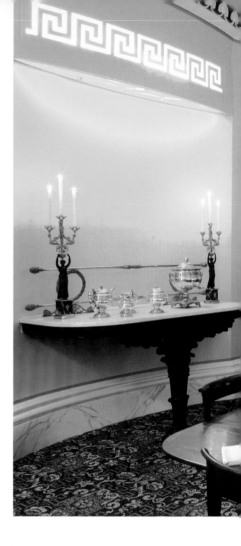

the day and highlights the English built-in, one-footed, marble-topped sideboard below. The theatrical feel of the room is also accentuated by the play of light created by the demi-lune niches, probably used to display large urns or other decorative objects; curved walls; and a three-dimensional

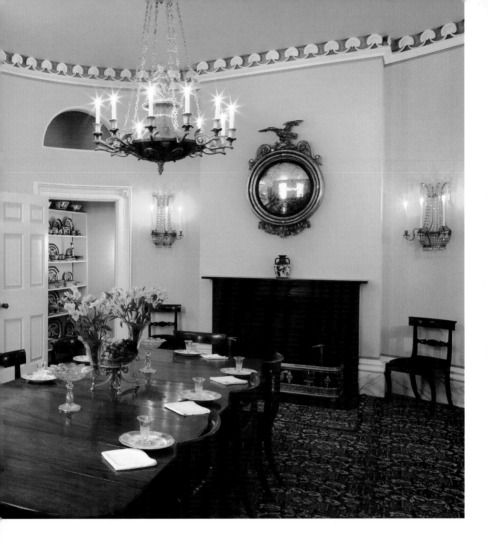

cornice that features plaster honey-suckle, or *anthemia*, patterned from classical motifs.

Specific rooms set aside for dining emerged among the wealthy in America in the mid to late eighteenth and early nineteenth centuries. A specialized dining room became a symbol of economic success because of the additional materials needed to build and furnish the space, as well as the costs associated with keeping a servant staff to move furniture and food—which, in Savannah, meant enslaved labor.

Family Dining Room

Richard Richardson's 1822 Bill of Sale of Household Furnishings referred to the room behind the dining room as "the back parlour or common room." Now called the family dining room, the space reflects the 1830s during George Welshman Owens' era. In addition to the recreated glazed wall finish, reproduced Brussels-woven period carpet and window treatments, the Owens family dining table and chairs add authenticity to the room.

Such common rooms served as the center of family life, with flexible furnishings to allow for various functions according to the time of day and use of the space. Adjacent to the butler's pantry, the family dining room would have been easily accessible to the back entry and kitchen, making it the most likely place where the family ate their meals. They also likely used the room for leisure and study.

In 1835, the Owens children would have been the following ages: Richard, 18, Mary Wallace, 16, John Wallace, 14, George Savage, 10, Sarah Jones, 7, and Margaret Wallace, 6. While the Owens children may have studied in the family dining room, the five

Above, ox-eye window. Family dining room, at right

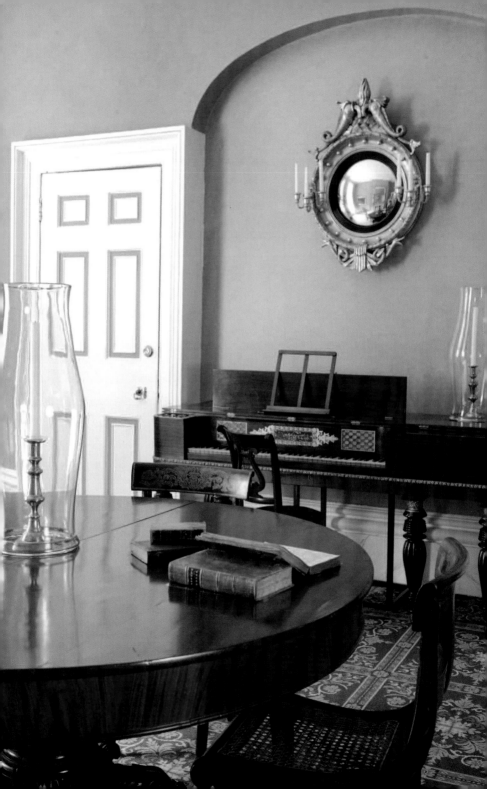

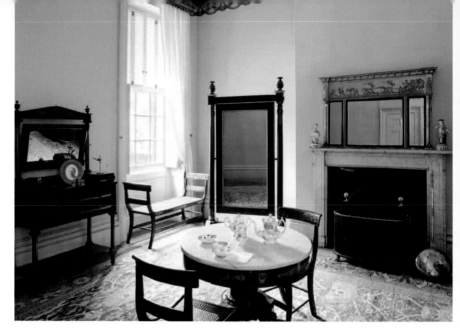

Two views of the master bedchamber, first floor

slave children in the household, including a girl named Fanny, would not have been allowed to read or write.

Instead, she and the other enslaved children may have been present in the room or rear hall awaiting instructions for work or play, perhaps grasping lessons learned by the Owens children. Possibly the enslaved children, if they were lucky, were permitted to play in the garden where old marbles have been found during archeological excavations.

Master Bedchamber

Across the rear hall, which features three "ox-eye" windows that provided ventilation and light to the rear rooms and basement stairway, a four-room suite created an elegant and luxurious master bedroom. The large room adjoined a bathing room complete with sink, tub, and possibly a shower. Two other smaller rooms were used to house a water closet (toilet) and dressing room. The cast-iron balcony was accessed from this room using jib doors located below the lower window sash, which allows for a clearance of nearly seven feet when

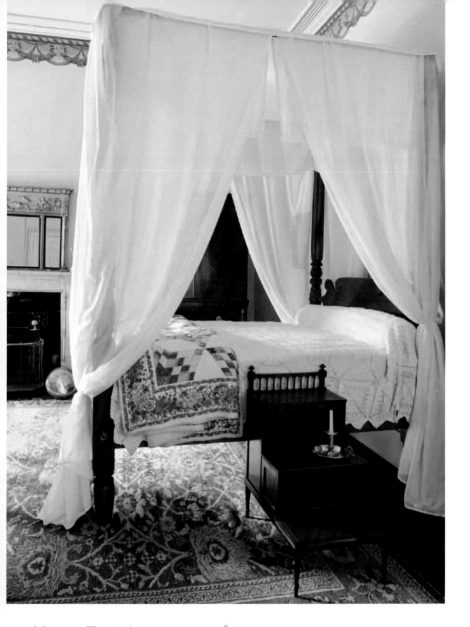

fully open. The window cornices in this room belonged to the Owens family, as well as the bed, table, chairs, and window seats.

The Marquis de Lafayette is believed to have stayed in this room when he visited Savannah in 1825.

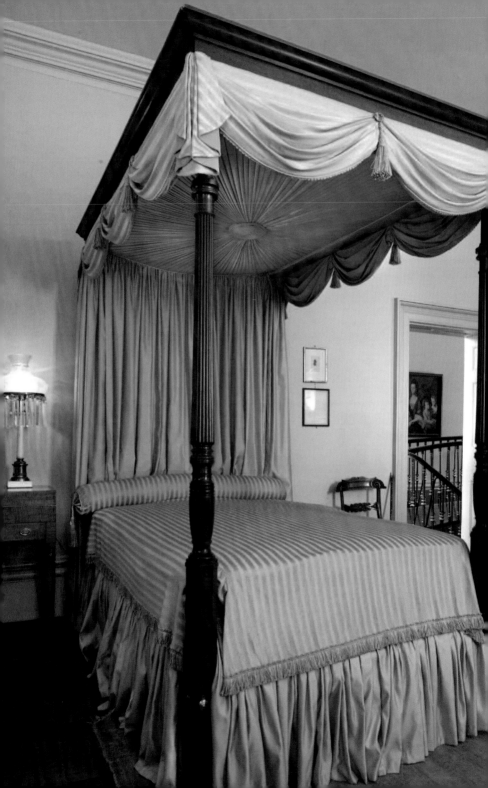

Second Floor

Four large rooms and several smaller rooms encompass the house's second floor. The bridge, as mentioned, connected the front and rear halls, or galleries, which were probably used as sitting areas. Three of the rooms on this floor were probably used as bedchambers, while the fourth, located at the rear of the north side of the house, was used as a library. In the early nineteenth century, home libraries symbolized education and accomplishment. This room features a grand gentleman's secretary (*page 28*), made in New York around 1820, and houses many books originally owned by the Owens family.

Each of the upstairs bedchambers probably held more than one bed to accommodate the many children and visitors known to have lived and stayed with the Richardson and Owens families. Two of these rooms are now on view. The southwest bedchamber features Lafayette memorabilia, including a terra cotta bust of the revolutionary hero, engravings, and a ceramic pitcher. The north bedchamber features a beautiful bed of Jamaican mahogany, made in New York or Philadelphia around 1825.

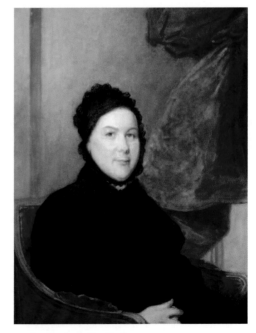

Opposite page:
Unknown maker (English)
Bed, c. 1800-1819
Mahogany, 96 x 84 x 54 ½ inches
Museum purchase, 1976

Attributed to James Frothingham
(American, 1786-1864)
Catharine Littlefield Greene Miller, c. 1809
Oil on panel, 32 ¾ x 25 ¾ inches
Museum purchase, 1947

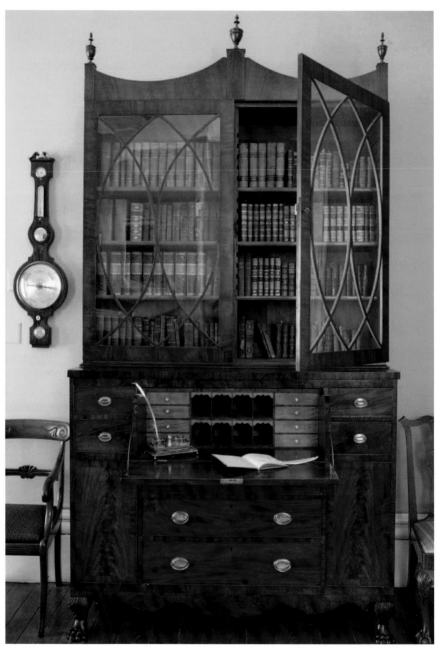

Unknown maker (American, New York City)
Secretary, c. 1820
Mahogany, satinwood veneer, tulip poplar
113 x 61 ¾ x 22 inches
Gift of Mrs. Joseph D. McGoldrick, 1978

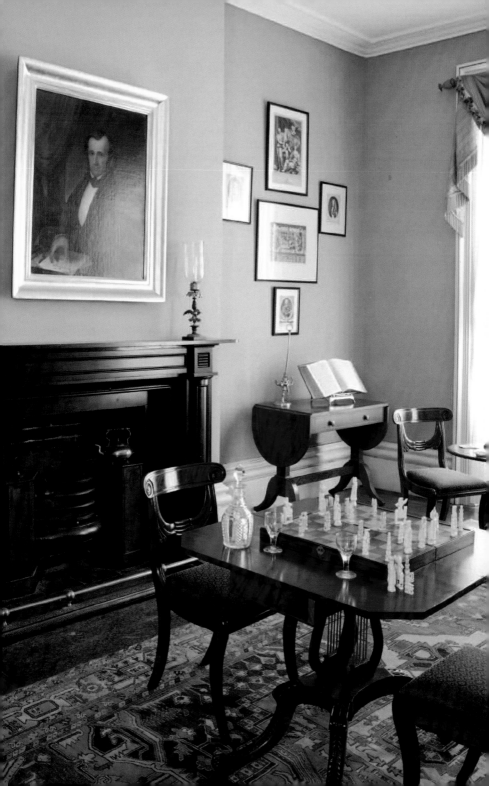

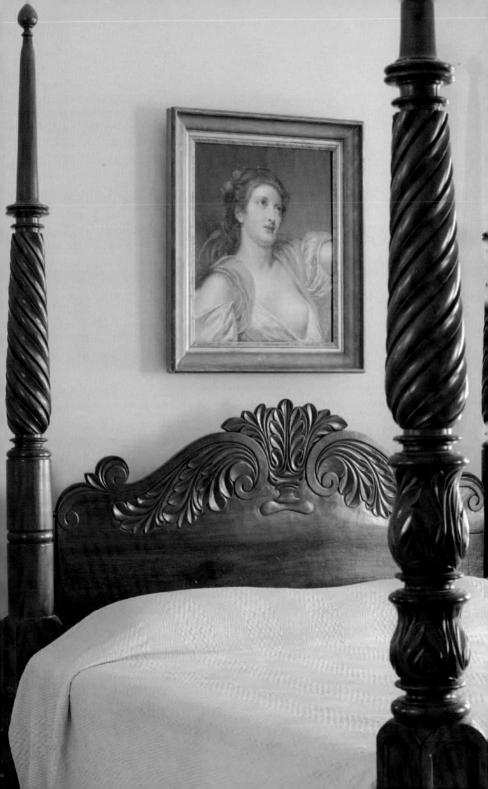

At the rear of the back hall are the three rooms Owens added in the 1830s. Originally these were probably used as additional bedrooms with a storage room in the center. Presently they are used as offices. An interior passage that leads from the "Lafayette" bedroom to the rear of the house originally enclosed three very small individual spaces, with one room housing a water closet and one a sink. A small anteroom on the passageway's rear/south side has a built-in ladder leading to a large attic.

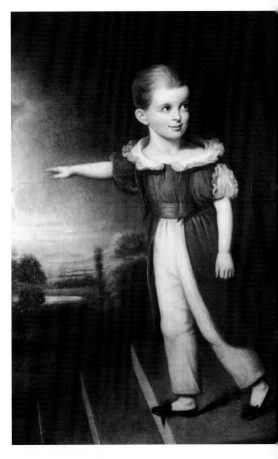

Unknown maker (American)
Stephen Percy Ellis *(detail), c. 1820*
Oil on canvas, 47 ¼ x 39 ⅛ inches
Bequest of Jane E. Smith, in memory of her husband, Raymond Telfair Smith

Portrait on opposite page:
Attributed to Jean Baptiste Greuze
(French, 1725-1805)
Portrait of a Young Woman, n.d.
Oil on canvas, 23 ⁹/₁₆ x 19 ⅜ inches
Gift of Mr. and Mrs. Van Vleck, 1962

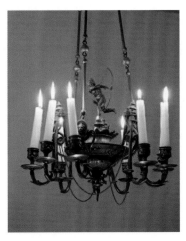

Unknown maker
Chandelier, n.d.
Brass, 64 x 16 ½ inches
Bequest of Margaret Thomas, 1951

Unknown maker (New York or Philadelphia)
Bed, c. 1825
Mahogany, 95 ¾ x 85 x 69 ½ inches
Gift of Mrs. Frank A. Hollowbush, 1977

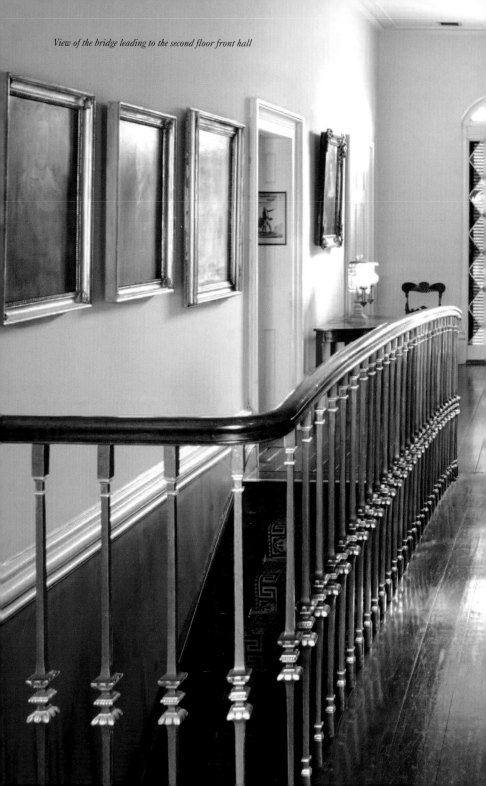

View of the bridge leading to the second floor front hall

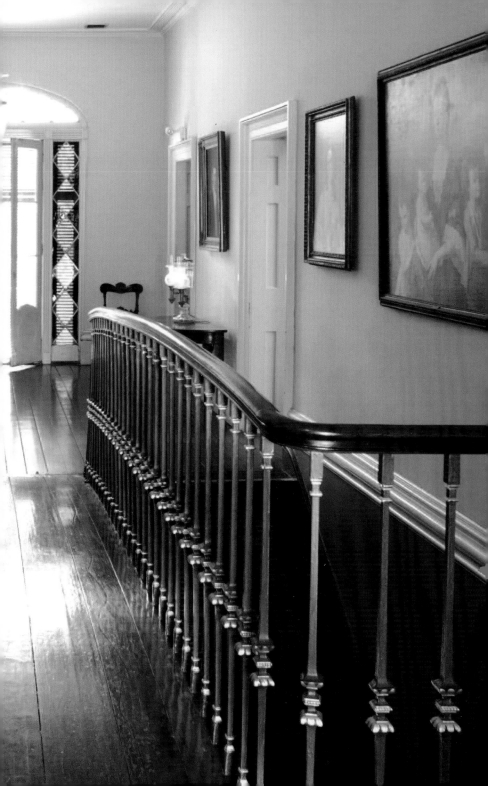

The Basement

Because the enslaved household spent much of their days cooking and cleaning in the raised basement, the windows in every room would have been a rare and important luxury, allowing light to penetrate the partially underground space. The basement consisted of a kitchen with a new, "modern" cast-iron stove imported from England; a laundry room featuring two intact stone sinks; and a bathing area that is today one large room, but originally consisted of four separate spaces: two rooms with marble tubs, a shower room, and a dressing room. The ruins of the largest cistern in the house can be seen in the central hall, along with the opening to the ice storage under the front porch. The basement also had a cellar, probably used for wine and other valuable goods such as sugar, and several small rooms (now one large room) that may have been used for storing dry goods, or for additional slave quarters. Neither of the latter spaces are currently on view.

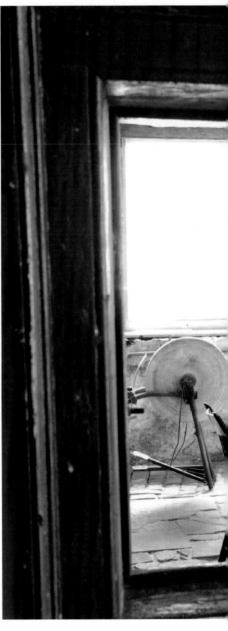

A view of the kitchen seen through the hall window

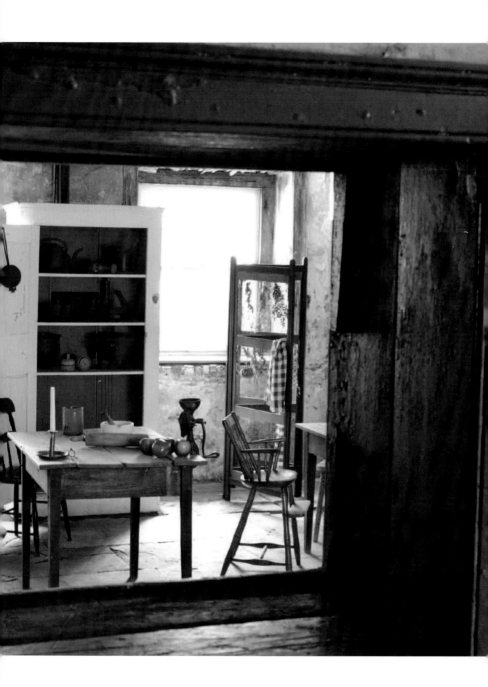

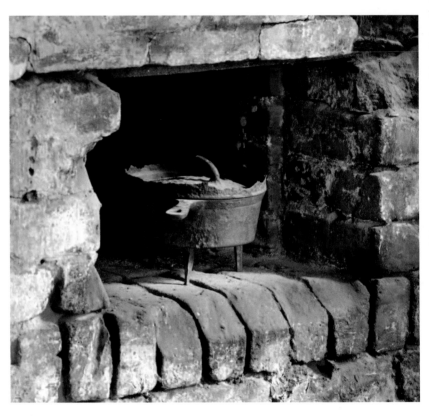

Details of kitchen oven, above; and built-in shelves and a wall-mounted kitchen tool, opposite page

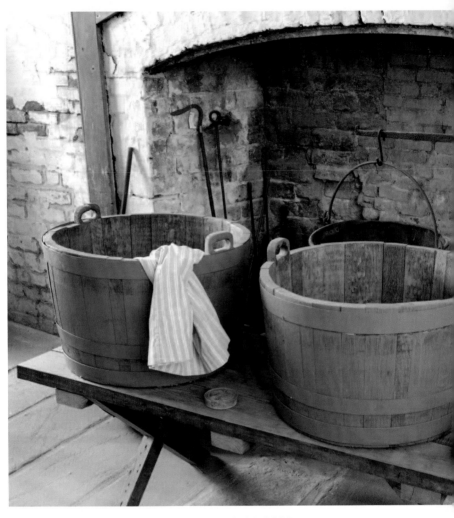

Details of the laundry room, including two original sinks and original shelving

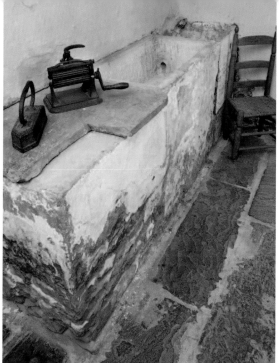

The Garden

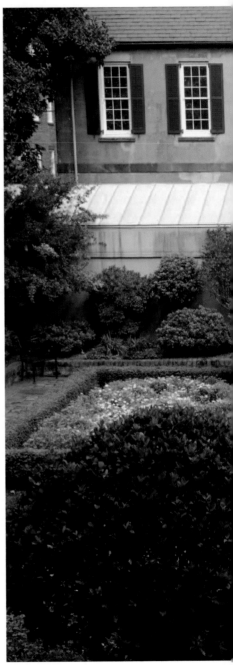

Originally, the space between the front and rear buildings was used as a service area. In addition to the privy, the space likely supported a kitchen garden and served as a place to hang laundry. A well at the rear of the garden near the slave quarters provided fresh drinking water for all the inhabitants of the house.

In 1956, Savannah's famous landscape designer Clermont H. Lee transformed the space into a formal English-inspired garden. Since then, a cadre of dedicated volunteers has maintained the garden.

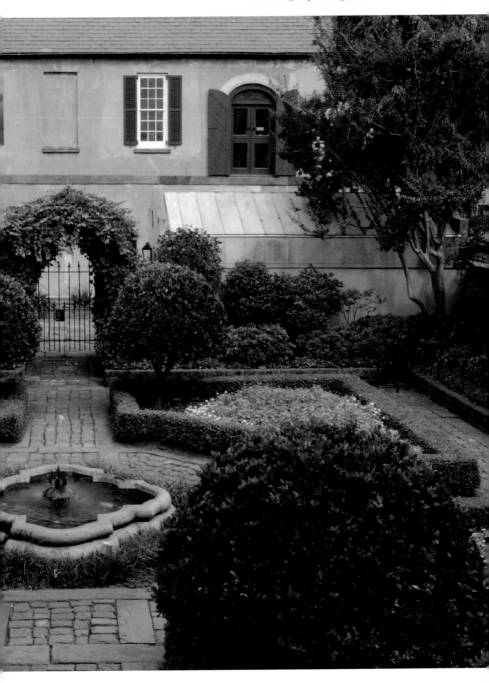

Slave Quarters / Carriage House

Just steps away from the main house—but a world apart from the sumptuous luxury enjoyed by the Richardson and Owens families—stood the slave quarters and the carriage house. The enslaved people who lived at this site had much smaller living accommodations than their white owners; however, their living arrangements in the urban environment were far more comfortable than most enslaved people living on plantations. In addition, the enslaved people at this site had connections to the outside world through the windows located on the first and second floor of their living space. Slave

Slave-made objects from the Acacia Collection of African Americana are displayed in the remains of the slave quarters.

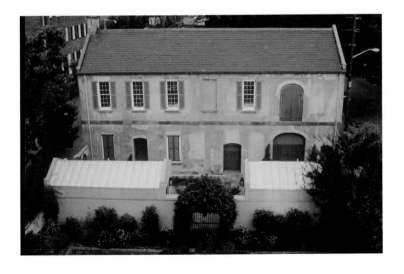

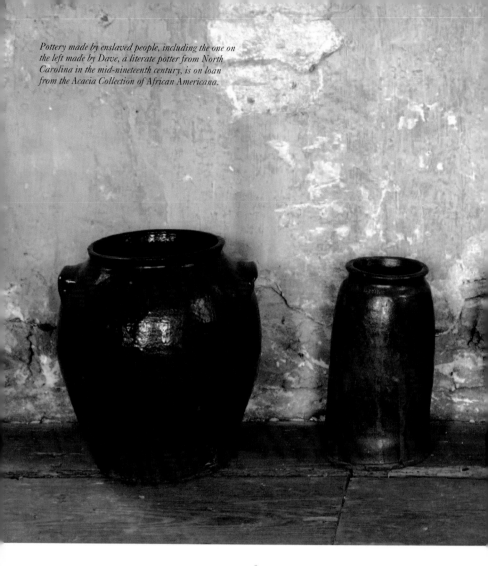

quarters at other town houses, such as the Aiken-Rhett House in Charleston, South Carolina, had no such access to the exterior world.

The outbuilding at the rear of the trust lot originally housed the two-story slave quarters in the north half of the building, and a stable, hayloft, and carriage house in the south half. On the first floor, the slave quarters were originally divided into one large room and two smaller rooms. The second

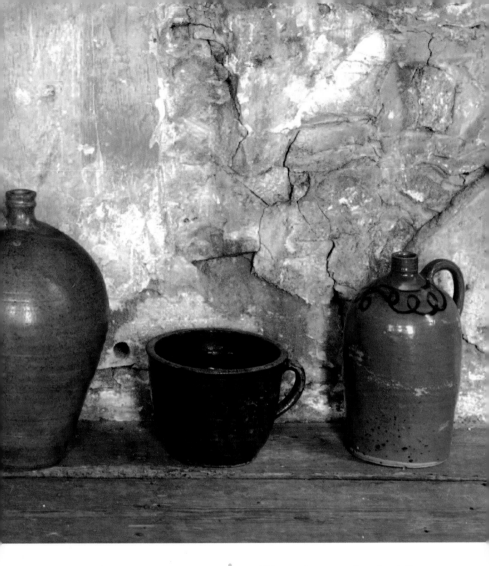

floor was divided into four spaces. The ceiling on the first floor of the slave quarters features the largest example of "haint" blue paint known to exist in America. "Haint" blue paint was believed to have spiritual properties in many African cultures, such as the ability to ward off evil spirits. In nine-teenth-century America, the paint—created by mixing indigo, lime, and buttermilk—was used on ceilings, around doors or windows, and even behind or under furnishings.

*Above, top, nineteenth-century red and ivory
coverlet, on loan from the Acacia Collection of
African Americana*

*Bricks and twentieth-century mortar, on the
second floor walls of the slave quarters, above*

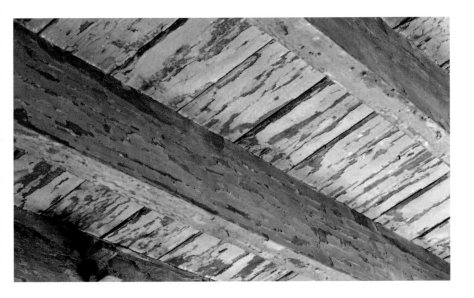

Above, top, exposed tabby in the former carriage house (now the museum store)

"Haint" blue paint on the ceiling of the first floor of the slave quarters, above

The People–

The Richardson Era

The first inhabitants of the Owens-Thomas House included owner Richard Richardson, his wife Frances Lewis Bolton Richardson, their children, and eleven enslaved men, women, and children. Most of what is known about Richard and Frances Richardson comes from existing public documents, yet we have no known personal letters or diaries to offer insight into their personal lives. What we do know, however, provides some clues to the living circumstances of a very wealthy Southern merchant family and those in their residence.

Born in Bermuda in 1785 to Robert and Mary Jones Richardson, Richard Richardson was the eighth of twelve children born to the same parents. His father's third marriage to Honarah Burrows produced five additional children. Richardson probably arrived in Savannah before 1804 and quickly gained financial and social stability in his new hometown. His business focused on the brokerage of property, both human and non-human, including land, buildings, slaves, and goods. Richardson partnered with his wife's brothers, Robert and James Bolton, her cousins, John and Curtis Bolton, and an associate from Bermuda, Durham T. Hall. Newspaper accounts and other sources show that Richardson also served as an attorney and president of two banks in Savannah: the Savannah Branch Bank of the United States and the Planter's Bank.

Other details of Richardson's life reveal a man with conflicted principles. He appears to be a strong supporter of family, friends and the community, while simultaneously participating in the nineteenth century's greatest immoral event—slavery and slave trading.

Examples of Richardson's civic-mindedness are indicated through various community causes, such as supporting the Savannah Poor House and serving on the relief committee after the great fire of 1820 leveled much of the city. Richardson also served in the

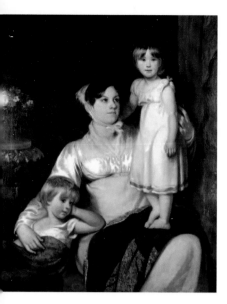

William Etty (British, 1787-1849)
Mrs. Robert Bolton *(Anne Jay Bolton, 1793-1859)* and Children, William and Anne, *1819*
Oil on canvas, 51 x 41 ¼ inches
Collection of the New York Historical Society

William Etty (British, 1787-1849)
Reverend Robert Bolton *(1788-1857), 1818*
Oil on canvas, 50 ¼ x 41 ¼ inches
Collection of the New York Historical Society

Georgia Militia, was a member of the Georgia Hussars, and briefly participated in the War of 1812. As a family man, Richardson took in at least two half-sisters and became the legal guardian of Charles Brooks after his father Benjamin Brooks, an associate of Richardson, died in 1817.

At age 26, Richard Richardson married Frances Lewis Bolton, age 17, in December 1811. Frances Bolton Richardson, the fourth of five children, was born in 1794 at the home of her parents Robert and Sarah McClean Bolton, who lived on Oglethorpe Square at the west corner of Abercorn and York streets. Her parents died when Frances was young and left her and her siblings money, slaves, and property.

When she married Richardson, Frances' brothers Robert and James Bolton, and cousins John and Curtis Bolton, ensured her financial security by overseeing a

prenuptial agreement signed by Richardson, relinquishing his rights to her inheritance. Although his actions may seem progressive, in reality his motivations, and those of his future in-laws and business partners, were probably more practical. Freezing control of Frances Richardson's property allowed the couple, and their future family, financial insurance should the need arise. Between 1812 and 1822, the Richardsons had six children, of which four— Frances, Richard, Robert, and James—survived childhood.

The remaining inhabitants of the Richardson household were enslaved people. The 1820 U.S. Census shows that eleven slaves lived at the newly-constructed Richardson home. Although the record does not name individuals, it does record sex and age ranges for these residents, and other documents provide clues to their possible identity. For example, Frances Richardson's father, Robert Bolton, left his daughter four named slaves in his will, and specifically noted the skills of two: Jack, a blacksmith; Cudjoe, a boy; Ben; and, George, a painter.

Frances was only six years old when her father died in 1802, so circumstances could have changed during the succeeding eighteen years, and these men may have left her possession.

Other documentation shows that Richard Richardson purchased several slaves during the years leading up to 1820. In 1814, he purchased several men: Will; Frank; Caesar and Dick, both ship carpenters; Henry, a blacksmith; and one woman, Venus, Caesar's wife. Perhaps some of these men helped build Richardson's grand home on Oglethorpe Square, and Venus worked as a house servant. In 1816, Richardson purchased two women: Rose, about 40, and her daughter Kate, about 22. However, with the knowledge that Richardson traded slaves, and without definitive documentation to prove their identities, the enslaved individuals who lived and worked at the Richardsons' home on Oglethorpe Square will probably remain unknown.

While Richardson actively contributed to the thriving institution of slavery in Savannah and the

South, several documented incidents add complexity to this aspect of his business. In 1805, Richardson witnessed the documentation of the sale of a girl, Rose, whom the purchaser, Ralph May, intended to free. Two years later, in 1807, Richardson purchased Rose's mother Rachel from Andrew Bryan, a free man of color, with the intent to free her. In 1809 and 1811, Richardson purchased two other young women—Amy, 19, and Peggy, 15, both Rachel's daughters—with the intent to free them. Finally, in 1812, Richardson purchased Andrew (Marshall, presumably), Rachel's husband, whom he freed on credit. Richardson purchased Amy, Peggy, and Andrew from John Bolton.

Documentation about the circumstances that led Richardson to assist this enslaved family does not exist, so we can only speculate as to his motivations. However, it appears that several community members, including Ralph May, Andrew Bryan (Andrew Marshall's uncle), John Bolton, and Richard Richardson worked jointly to free this family. Regardless of

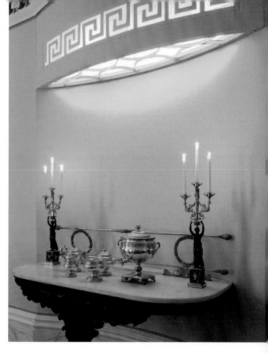

Unkown maker (English)
Marbletop sideboard, c. 1819
Mahogany, white pine, brass, marble
39 ½ x 72 x 30 inches
Bequest of Margaret Thomas, 1951

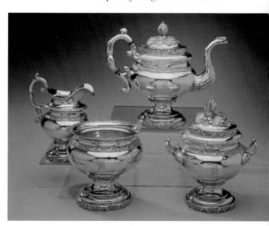

John A. Crawford (American, active New York,
1815-1836); Philadelphia, 1837-1843)
Tea service, c. 1815-20
Silver, various dimensions
Engraved on each piece: "R";
Inscribed under teapot: "F L B Richardson"

the circumstances, these efforts indicate the respect and admiration Andrew Marshall earned from Savannahians of both races, free and enslaved.

Born into slavery in South Carolina in 1755, Andrew Marshall was the son of an enslaved woman and a white overseer. Marshall had been promised freedom on two occasions, but circumstances did not allow his emancipation. In Savannah, he eventually became the coachman for Frances Richardson's parents, Robert and Sarah Bolton. Marshall served as the pastor of the First African Baptist Church for 30 years, and preached to the Georgia State Legislature as well as to other white congregations. His service to the black community in Savannah is noted by the fact that he baptized about 3,800 people, converted over 4,000 people, and married 2,000 couples.

Richard and Frances Richardson spent only a brief time in their spectacular home on Oglethorpe Square, which they probably moved into in 1819. Suffering from financial setbacks, Richardson decided to pursue opportunities in New

Orleans. In 1822, while Richardson was on a trip to Louisiana to arrange to move his family to New Orleans, Frances Richardson died of a fever in Savannah. His young daughter Rebecca also died later that year in New Orleans. The Richardsons had lost another child, John, in 1819.

Richardson sold his house and its contents to his brother-in-law and partner, Durham T. Hall, in 1822. Afterwards, records indicate that Richardson continued to settle his business in Savannah, but spent little if any time in the city. In 1833, Richardson died at sea on a voyage from Le Havre, France, to New Orleans.

The Maxwell Era

Hall's ownership of the former Richardson mansion was only temporary. In 1823, he sold the furnishings of the house to John H. Morel, and in 1824, the Bank of the United States took over the house. For the next six years, Mrs. Mary Maxwell, a widow, leased the property and ran it as an elegant lodging house. Maxwell had run

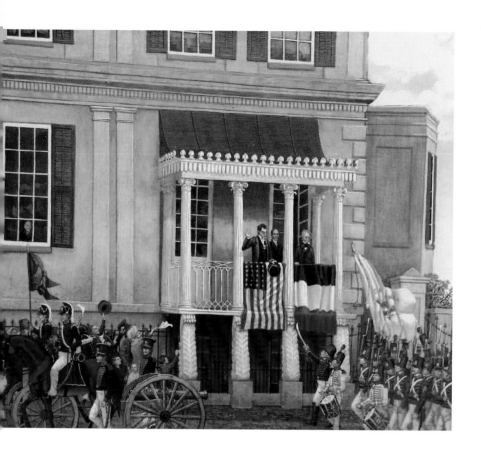

other boarding houses—considered to be a respectable business for widows—such as the Archibald Bulloch house, another Jay-designed residence. At the Richardson mansion, Maxwell often hosted businessmen and dignitaries, including the famous Revolutionary War hero, Marquis de Lafayette, who enjoyed international celebrity and was a guest of the city in 1825. Lafayette is said to have

Preston Russell (American, born 1941)
LaFayette at the Owens-Thomas
House, 1825, *1992*
Acrylic on canvas
18 x 24 inches
Collection of Steven Bader

addressed the citizens of Savannah on March 19, 1825, from the cast-iron balcony on the south side of the house. Lafayette's stay at the house led some to call the building "Lafayette Hall."

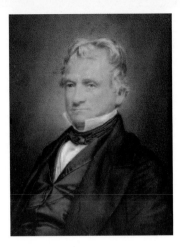

George Welshman Owens (1786-1856)

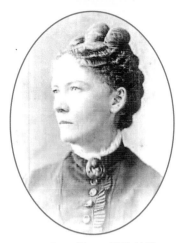

Margaret Owens Thomas (1829-1915)

The Owens Era

In 1830, George Welshman Owens—congressman, lawyer, planter, and mayor of Savannah—purchased Richardson's former mansion for $10,000. Owens, an illegitimate child born in 1786 to Owen Owens and Penelope Newdigate, lived a privileged life, receiving the finest education in England as well as financial and moral support from his father. Owens and his wife Sarah Wallace, born the third of six children in 1789, were married in 1815. They lived on York Street, in Anson Ward, and probably watched the construction of the Richardson mansion from 1816-1819 with great interest.

A newspaper article from the late nineteenth century states Owens' motivation for purchasing the house: *the impulse to own and protect in days to come the house which had grown to be regarded as one of the pillars of the early structure of Savannah, which stood for historic value as well as intrinsic worth.*

The Owenses would have known the first owners of the house, both socially and through business. Not only did the Owens and Richardson families live in close proximity, they both attended the same church, Independent Presbyterian. In business, on at least two occasions, Owens witnessed the documentation of transactions conducted by Richardson.

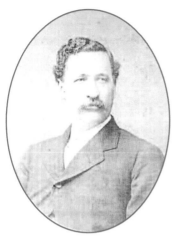
John Thomas (1835-1884)

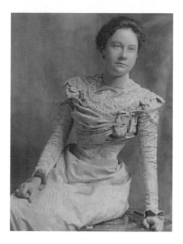
Margaret Gray Thomas (1871-1951)

While Owens may have been interested in preserving an important Savannah icon, he was also concerned with the task of acquiring a commodious home for his large family, which included six children, all of whom lived to adulthood: Richard Wallace (1817-1883), Mary Wallace (1819-1903), John Wallace (1821-1862), George Savage (1825-1897), Sarah Jones (1828-1900), and Margaret Wallace (1829-1915). The prominent location, distinguished architecture, advanced plumbing, and cheap price, compared to the reportedly $50,000 original cost, had to be motivating factors in addition to any altruistic preservation concerns he harbored. After nearly three years of work, including the addition of three rear rooms on the upper

story, the Owens family moved into their new home in 1833. Although George Owens owned the house, his wife Sarah took on the responsibility of managing the home, as well as other business affairs, because he spent so much time traveling.

As during the Richardsons' time, the Owens household included many enslaved individuals who catered to the comfort and well-being of the white family for whom they cooked, cleaned, drove, gardened, shopped, and cared. During the 1830s, the enslaved inhabitants at the Owens house numbered between ten and thirteen, half of whom were children.

While evidence about their lives is scant, public documents as well as

Owens family letters shed some light on the identities of these enslaved people. One possible female slave could have been Lydia, "a Negro wench," and her children, who were given to Owens' mother by his father for use during her lifetime. Lydia may have reverted to George Owens upon his mother's death in 1816. Family correspondence includes the names of a nurse, Emma, to whom George's son John Owens left $100 in his will; Mom Kate, a nanny; Fanny, a girl; Diane, probably the cook; and three men, Gordon, Peter, and Dick. In his will, George Welshman Owens left $100 each to Emma, Diane, and Peter, and $50 to Dick.

In addition to the urban slaves, George Owens owned numerous plantations and hundreds of slaves were used to maintain his cotton and rice production. Further research into the details of the management and movement of the slaves on each of his plantations and in his Savannah home provides further insight into the complicated and inhumane activities conducted in antebellum American history. Like Richardson, however, Owens, at least on two occasions, tried to keep enslaved families intact, as indicated through correspondence with his wife Sarah. In 1818, while working to settle his father's estate on Ossabaw Island, Owens instructed Sarah, "*you will buy Smart's wife and Sampson's to comply with a promise I have made them.*" Later that year he wrote, "*you must contrive to purchase those (say three or four) who are connected with our Negroes.*"

George Welshman Owens died in 1856, leaving his estate to his wife Sarah during her lifetime. In 1865, three years after her death—as stipulated in Owens' will—his executors, sons John Wallace and George Savage, began to execute his will, which took fifty years. His vast and complicated estate included extensive real estate holdings, hundreds of slaves, and furnishings. The longevity of the settlement occurred, in part, as the result of his children's wishes to keep his home and furnishings together for his daughters—Sarah, Mary, and Margaret and her family—who remained in the house.

Margaret Owens married Dr. James Gray Thomas (1835-1884)

in 1865. Like Richard Richardson, James Thomas signed a prenuptial agreement, witnessed by her brother George, relinquishing rights to her inheritance. The couple had five children, and two daughters, Mary Bedford (Maude) Thomas (1868-1917) and Margaret Gray (Meta) Thomas (1871-1951), survived childhood. After the death of Sarah and Mary, tensions arose between Margaret Owens Thomas and the heirs of George Savage Owens as to the distribution of the estate, including the house in which the Thomas family lived. In 1907, a lawsuit that went to the Georgia Supreme Court ruled in favor of Margaret Owens Thomas, which settled the dispute, giving her sole ownership of the house and its furnishings.

The Legacy

Margaret Gray (Meta) Thomas, the sole heir to the Owens-Thomas House, died in 1951. Her will gave her home to the Telfair Academy of Arts and Sciences (now Telfair Museum of Art) "to be by it preserved, maintained and used as a museum in perpetuity for the benefit and use of

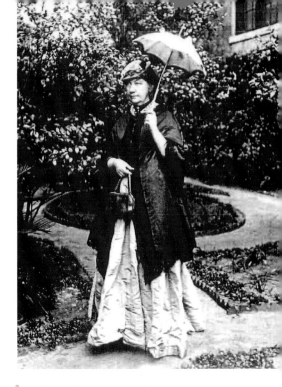

the public as a memorial to my grandfather, George W. Owens, and to my father James G. Thomas, to be called the Owens-Thomas Museum." Recognizing the historic and architectural significance of her home, Thomas stipulated that should the Telfair Academy of Arts and Sciences decide to reject her gift, then she would give the house to the United States of America for use as a museum. Thomas made this bequest four years before the Savannah Historic Foundation organized to save the Davenport House (1955), making her a leader in Savannah's historic preservation movement.

Above, Margaret Gray Thomas dressed as a nineteenth-century woman, photographed mid-twentiethth century

The Telfair Academy of Arts and Sciences accepted Thomas' bequest and the Owens-Thomas House opened its doors to the public in 1954, after two years of intensive work to create an authentic Regency-era interior. Over fifty years later, the Owens-Thomas House is visited by nearly 60,000 people a year. Beginning in 1992, the museum converted the carriage house into a museum store and opened the original slave quarters. Maintenance to stabilize and pre-serve the exterior of both buildings is ongoing. The preservation and restoration of the interiors to the house is underway to interpret the site to the 1820s and 1830s. The front two rooms of the house are interpreted to the Richardson era during the 1820s, while the remainder of the house is, or will be, interpreted to the 1830s, the Owens era. Research and interpretation about the people who lived and worked at the house, including the enslaved inhabitants, is ongoing.

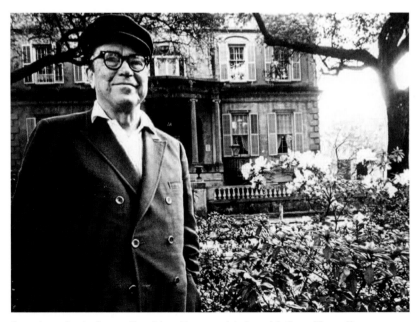

Songwriter and native Savannahian, Johnny Mercer, stands in front of the Owens-Thomas House.

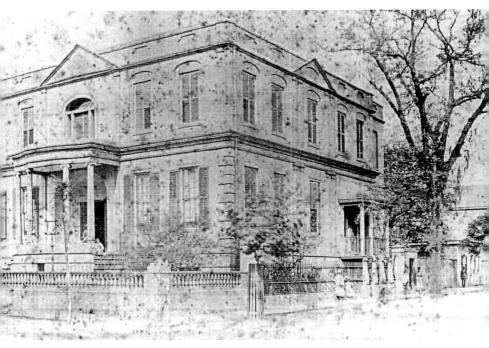

A late nineteenth-century photograph of the Owens-Thomas House, showing people on the front porch and others standing along the south side of the house

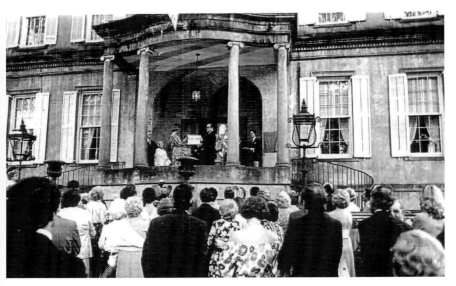

The Owens-Thomas House received National Historic Landmark designation in 1976.

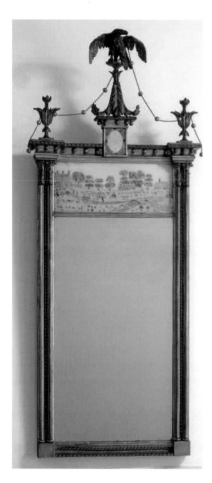

Unknown maker (American, New York, probably Albany)
Looking glass, one of a pair, c. 1800-1810
Wood, gesso, gilt, reverse-painted glass, mirrored glass, 66 x 25 x 2 inches
Gift of James H. McKenna Jr., 1997

Opposite, top: Samuel Kirk & Son (American, Baltimore, active 1846-1861 and 1868-1979)
Monteith, c. 1880-90
Silver, 5 x 7 ⅜ inches
Bequest of Margaret Thomas, 1951

Opposite, bottom: Scroll-back cane sofa, c. 1805-10
Mahogany, cane, 30 ¾ x 77 x 21 ¼ inches
Museum purchase, 1964

The Collections

The furnishings on view in the Owens-Thomas House date from about 1790-1840 and are mostly American-made. This time period allows the museum to narrow the interpretation of the house to when the Richardson and Owens families first lived there in the 1820s and 1830s. Only two items remaining at the museum originally belonged to the Richardsons: the English built-in sideboard in the dining room, and a silver tea set made by John Crawford in New York (*page 50*). Each piece displays an engraved initial "R" for Richardson. Additionally, the teapot's underside confirms that the set belonged to Frances Lewis Bolton Richardson as indicated by the engraved notation "F L B Richardson." In contrast to that meager representation, nearly 35% of the objects on view at the Owens-Thomas House belonged to the Owens family.

The remainder of the collection consists of objects donated or lent to the Telfair Museum of Art. Many of these items belonged to wealthy Savannah families during the same time period, such as the

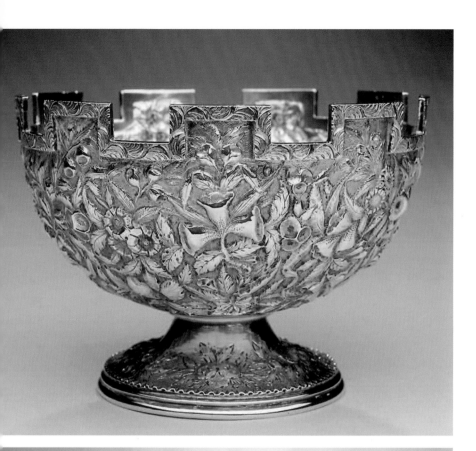

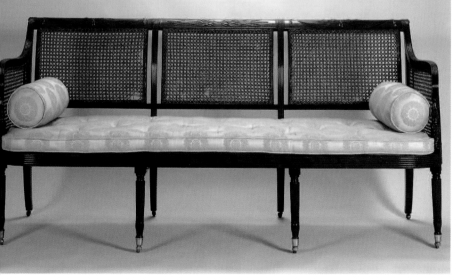

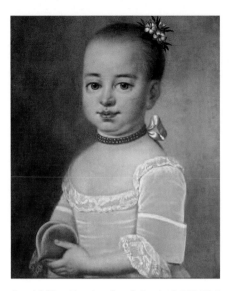

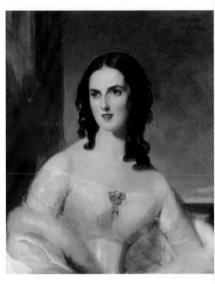

Jeremiah Theus (American, born Switzerland, 1719-1774)
Peggy Wagner, *c. 1750-1760*
Oil on canvas, 16 ⅛ x 14 ⅛ inches
Gift of Emma Cheves Wilkins, 1946

Thomas Sully (American, born England, 1783-1872)
Guilelmina Pickett Dalrymple Magruder, 1852
Oil on canvas, 30 x 25 inches
Gift of Elizabeth de C. Wilson, 1980

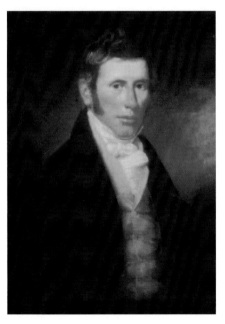

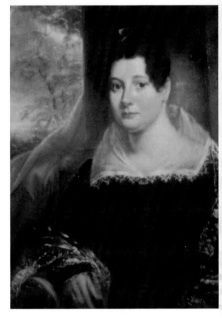

Unknown artist (possibly John Wesley Jarvis 1780-1840)
Henry McAlpin, *c. 1820-1831*
Oil on canvas, 30 ⅛ x 25 ⅛ inches
Gift of Sallie M. McAlpin, 1951

Unknown artist (possibly John Wesley Jarvis 1780-1840)
Ellen McInnis McAlpin, *c. 1820-1831*
Oil on canvas, 30 ⅛ x 25 ⅛ inches
Gift of Sallie M. McAlpin, 1951

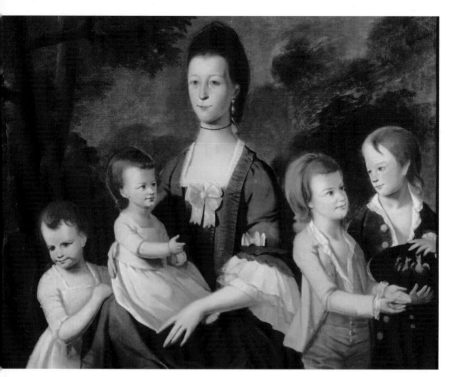

Henry Benbridge (American, 1743-1812)
Mary Bryan Morel and Her Children, *c. 1773*
Oil on Canvas, 40 x 50 ¾ inches
Gift of Caroline L. Woodbridge, 1957

Philadelphia-made extension dining table on view in the dining room that was once owned by the Screven family, or the Duncan Phyfe secretary, on view in the drawing room, that once belonged to Mary Telfair. Most, if not all, of the furnishings at the Owens-Thomas House were made in America, primarily due to the relatively easy coastal passageway to ports in the North.

In addition, with the exception of a modest silver business and a few plain pieces of furniture possibly made in Savannah, little evidence exists to suggest a thriving furnishings industry in the city. The lack of this high-end market provides evidence that the well-traveled, elite families in the community were prone to the fashions of the day as dictated in other regions of the world.

Suggested Reading

Coleman, Feay Shellman. *Nostrums for Fashionable Entertainments: Dining in Georgia, 1800-1850*. Savannah, Georgia: Telfair Academy of Arts and Sciences, Inc., 1992.

Garrett, Elisabeth Donaghy. *At Home: The American Family 1750-1870*. New York: Harry N. Abrams, Inc., 1990.

Johnson, Wittington B. *Black Savannah: 1788-1874*, Fayetteville, Arkansas: The University of Arkansas Press, 1996.

McCullough, Hollis Koons, editor, *Collection Highlights: Telfair Museum of Art*, Savannah, Georgia, 2005.

Parissien, Steven. *Regency Style*. Washington, D. C.: The Preservation Press, 1992.

Talbott, Page. *Classical Savannah: Fine & Decorative Arts, 1800-1840*. Savannah, Georgia: Telfair Museum of Art, 1995.

● ●

Telfair Books © 2009

All rights reserved. This book may not be reproduced in whole or in part, in any form, without permission from the publisher.

Photography by Richard Leo Johnson/Atlantic Archives: *pages 2, 4, 10, 12, 14-16, 18-26, 28-42, 44-47, 51, back cover*

Cover photograph by Attic Fire

ADDITIONAL PHOTOGRAPHY BY:
Peter Harholdt: *pages 4, 27, 51, 60, 61, 62, 63*
Bailey Davidson: *page 8*
Daniel L. Grantham, Graphic Communications: *pages 30, 62*
Bob Morris, Savannah News-Press: *page 59*

ACKNOWLEDGMENTS:
Silver tea service, page 51: Museum purchase with funds from Mrs. Gordon Carson, Miss Sara Cunningham, Miss Dorothy Farr, Mrs. James Glover, Mrs. Hunter Harris, Mr. Tom Hilton, Mr. Lester Karrow, Mrs. Richard Meyer, Mrs. Henry L. Richmond, Mrs. Fred J. Robinson, Miss Margaret Stiles, Mrs. Rufus Wainwright, and Mr. and Mrs. Descombe Wells, 1956
The reinterpretation of the listed rooms was made possible through funding from the following:
　Drawing Room: The Dana Foundation
　Front Hall: Rosa Lee F. Thorpe
　Dining Room: Mr. and Mrs. William M. Sander
　Family Dining Room: Telfair Academy Guild (TAG) in honor of Dr. Diane Lesko,
　　Telfair Museum of Art director, 1995-2006.

Design and production by Pinafore Press / Janice Shay
Editing by K.W. Oxnard

ISBN-13 978-0-933075-10-8
ISBN-10 0-933075-10-3

Printed in Canada

Published by Telfair Books
Distributed by the University of Georgia Press
www.ugapress.uga.edu